Coloring Tools

Using whatever medium you like, you can take these delightful drawings into a new world of color. Different coloring tools can really lend different effects and moods to an illustration—for example, markers make a vibrant statement while colored pencils offer a softer feel. Have fun experimenting with some of these mediums:

- Markers
- Colored pencils
- Colored pens
- Gel pens
- Watercolors
- Crayons

Markers
Dual Brush Markers (Tombow).
Bright Tones.

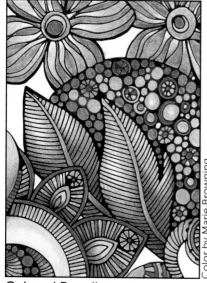

Colored Pencils
Irojiten Colored Pencils (Tombow).
Vivid Tones.

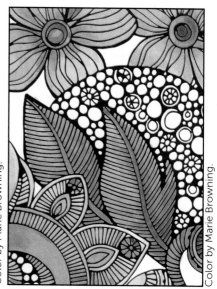

Watercolors
Watercolors (Winsor & Newton).
Analogous Tones.

Color Theory

With color, illustrations take on a life of their own. Remember: when it comes to painting and coloring, there are no rules. The most fun part is to play with color, relax, and enjoy the process and the beautiful finished result. Feel free to mix and match colors and tones. Work your way from primary colors to secondary colors to tertiary colors, combining different tones to create all kinds of different effects. If you aren't familiar with color theory, here is a quick, easy guide to the basic colors and combinations you will be able to create.

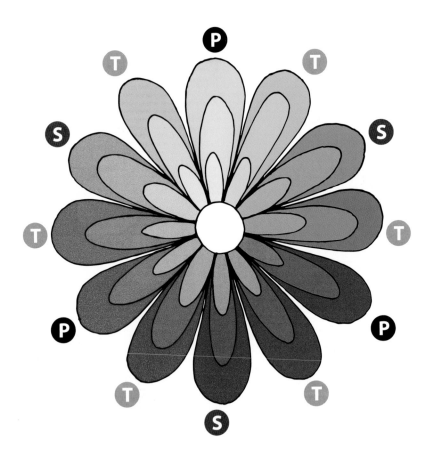

Primary colors: These are the colors that cannot be obtained by mixing any other colors; they are yellow, blue, and red.

Secondary colors: These colors are obtained by mixing two primary colors in equal parts; they are green, purple, and orange.

Tertiary colors: These colors are obtained by mixing one primary color and one secondary color.

Coloring Ideas

Color each section of the drawing (every general area, not every tiny shape) in one single color. This will take less time and can change the overall look of the drawing.

Within each section, color each detail (small shape) in alternating colors. This creates a nice varied and symmetrical effect.

Leave some areas white to add a sense of space and lightness to the illustration. Just because it's there doesn't mean it has to be colored!

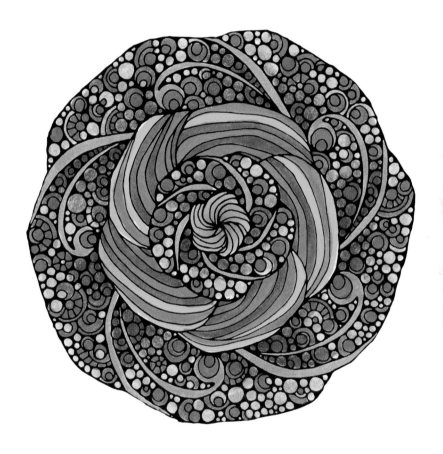

Dual Brush Markers (Tombow), Irojiten
Colored Pencils (Tombow). Bright Tones.
Color by Marie Browning.

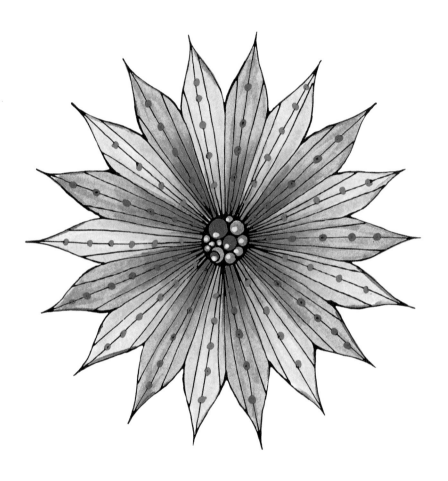

Dual Brush Markers (Tombow), Gel Pens (Sakura).
Cool Tones. Color by Marie Browning.

Watercolors (Winsor & Newton), Irojiten
Colored Pencils (Tombow). Warm Tones.
Color by Marie Browning.

Dual Brush Markers (Tombow), Gel Pens (Sakura),
Irojiten Colored Pencils (Tombow). Vivid Tones.
Color by Marie Browning.

The beauty of the natural world
lies in the details.

—Natalie Angler

In all things of nature
there is something
of the marvelous.

—Aristotle

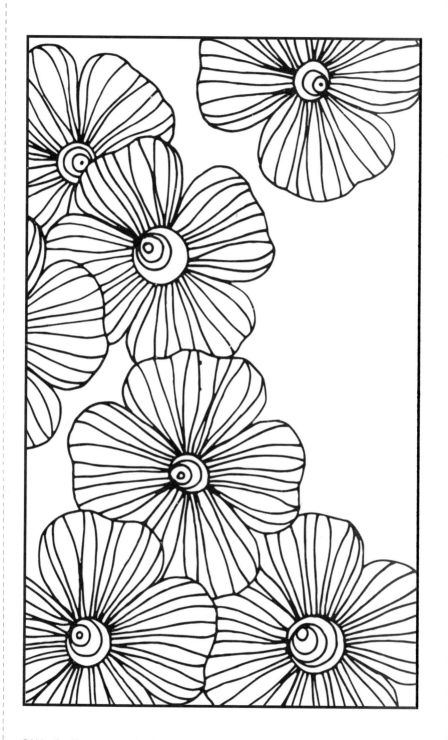

Every flower is a soul
blossoming in nature.

—Gérard de Nerval

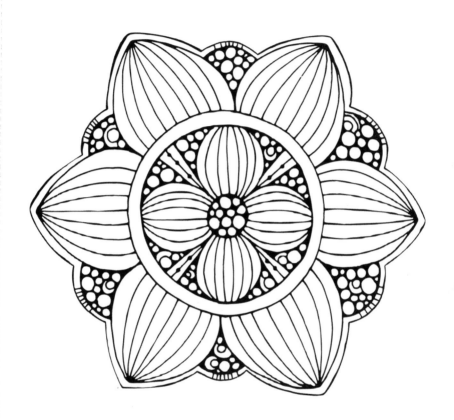

One sees great things from the valley;
only small things from the peak.

—G. K. Chesterton

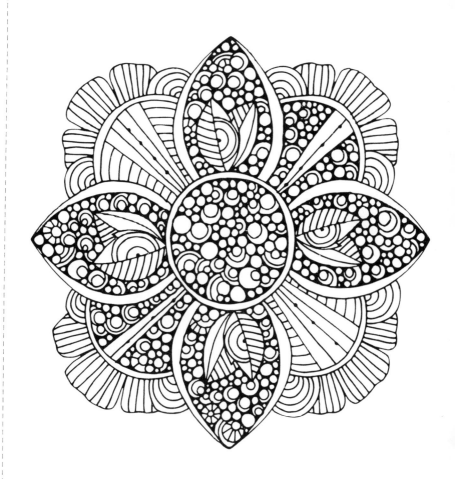

At some point in life, the world's beauty becomes enough.

—Toni Morrison

If you are not willing to learn,
no one can help you.
If you are determined to learn,
no one can stop you.

—Unknown

Flowers are the music of the ground,
from earth's lips spoken without a sound.

—Edwin Curran

If you never chase your dreams,
you'll never catch them.

—Unknown

I go to nature to be soothed and healed,
and to have my senses put in order.

—John Burroughs

Happiness...is not another place
but this place, not for another hour
but this hour.

—Walt Whitman

I must have flowers, always, and always.

—Claude Monet

Where flowers bloom so does hope.

—Lady Bird Johnson

Life is the art of drawing
without an eraser.

—Unknown

Nature never hurries.
Atom by atom, little by little
she achieves her work.

—Ralph Waldo Emerson

You can, you should, and if you're
brave enough to start, you will.

—Stephen King

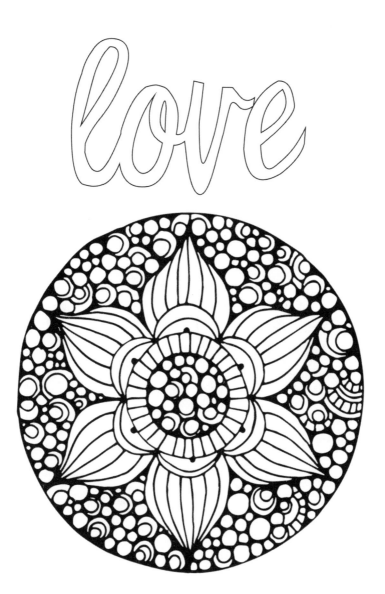

Follow your heart,
but take your brain with you.

—Unknown

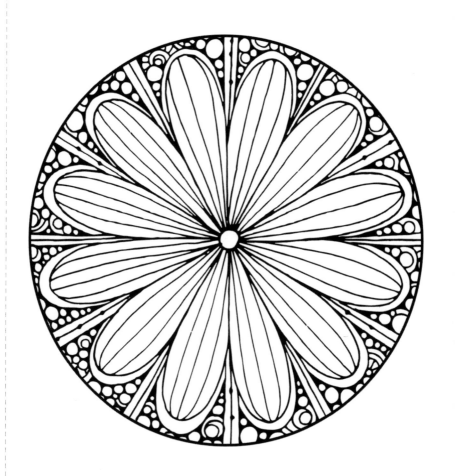

There are some things you learn best
in calm, and some in storm.

—Willa Cather

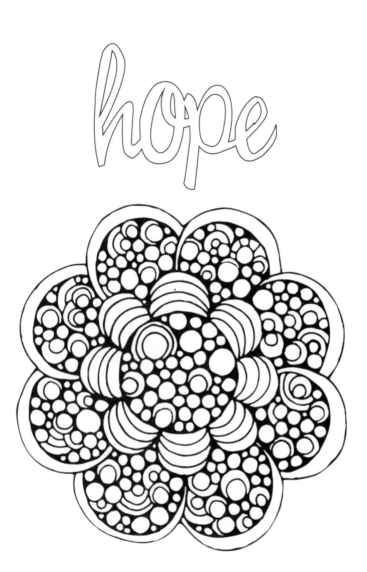

Hope appears on the horizon each morning
in the form of a brand new day.

—Unknown

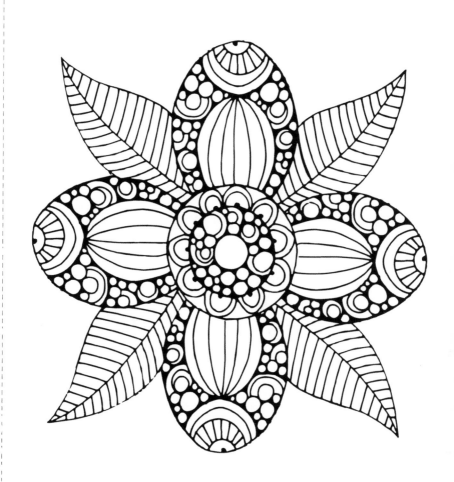

Wisdom begins in wonder.

—Socrates

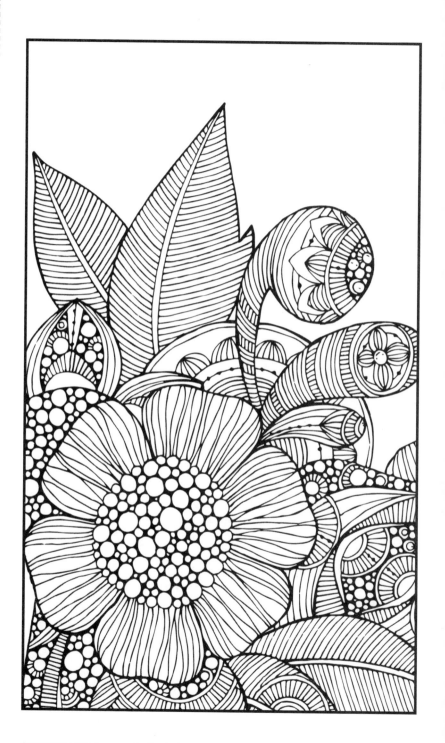

If you look the right way,
you can see that the whole world
is a garden.

—Frances Hodgson Burnett, *The Secret Garden*

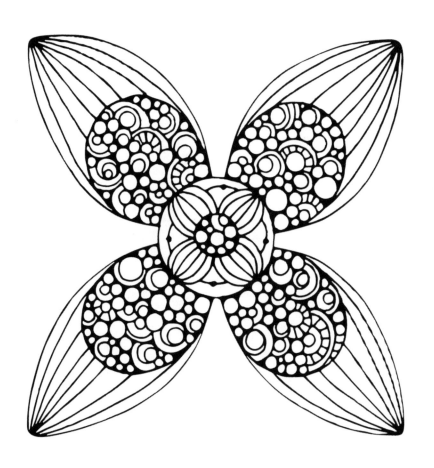

Autumn is a second spring
when every leaf is a flower.

—Albert Camus

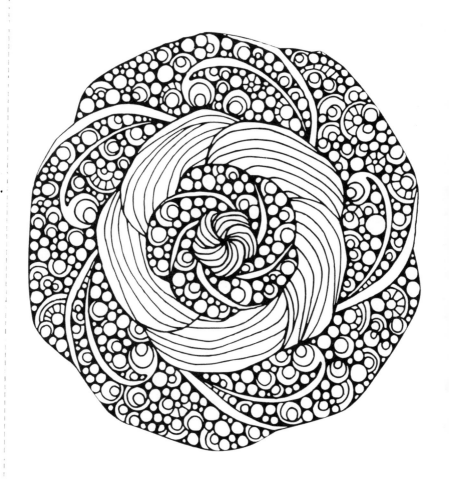

Look deep into nature, and then you will
understand everything better.

—Albert Einstein

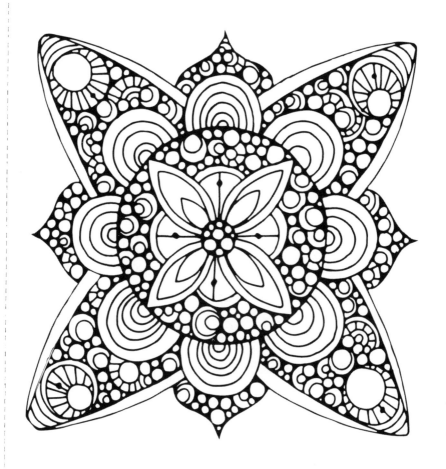

All my life through,
the new sights of Nature
made me rejoice like a child.

—Marie Curie

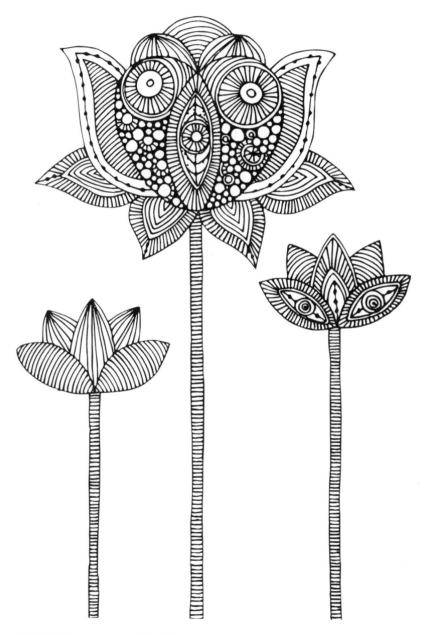

Let us dance in the sun,
wearing wild flowers in our hair...

—Susan Polis Schutz

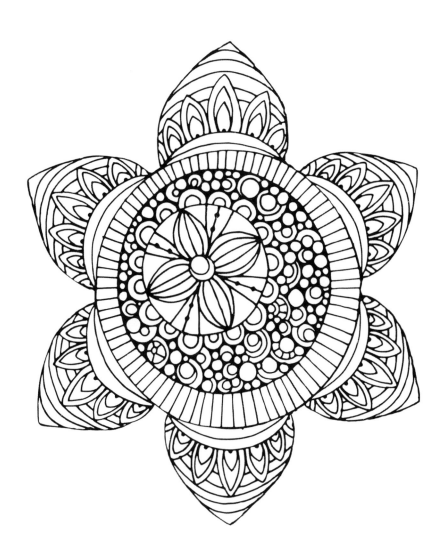

The sun, with all those planets
revolving around it and dependent
upon it, can still ripen a bunch
of grapes as if it had nothing else
in the universe to do.

—Galileo

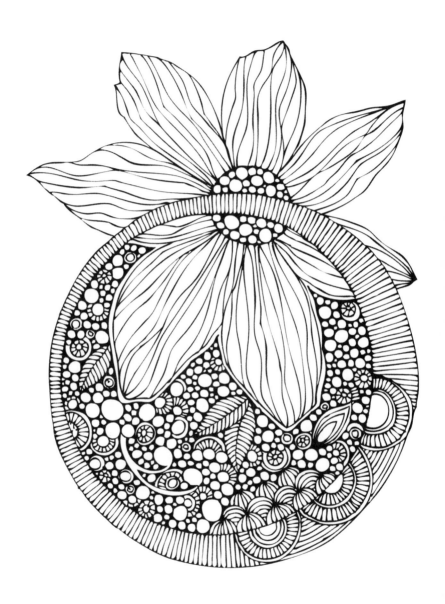

Happiness held is the seed;
happiness shared is the flower.

—John Harrigan

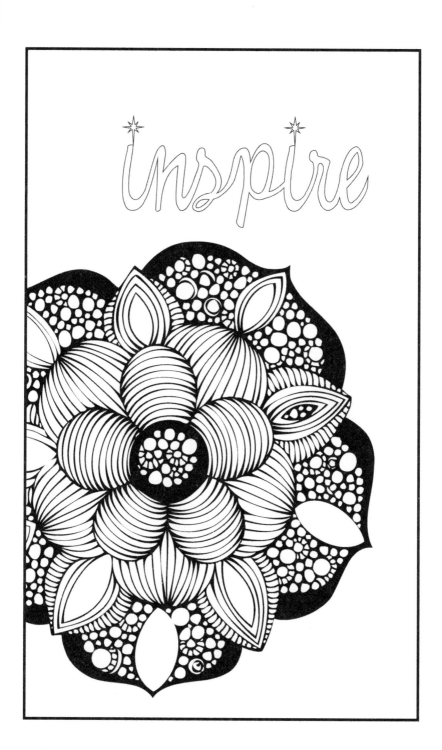

Spread love everywhere you go;
let no one ever come to you
without leaving happier.

—Mother Teresa

If we could see the miracle
of a single flower clearly, our
whole life would change.

—Buddha